Understanding
Islam™

Islamic Customs and Culture

Jason Porterfield

ROSEN
PUBLISHING®
New York

Published in 2009 by The Rosen Publishing Group, Inc.
29 East 21st Street, New York, NY 10010

Copyright © 2009 by The Rosen Publishing Group, Inc.

First Edition

Library of Congress Cataloging-in-Publication Data

Porterfield, Jason.
Islamic customs and culture / Jason Porterfield.—1st ed.
 p. cm.—(Understanding Islam)
ISBN-13: 978-1-4358-5065-1 (library binding)
ISBN-13: 978-1-4358-5383-6 (pbk)
ISBN-13: 978-1-4358-5387-4 (6 pack)
1. Islam—Customs and practices. 2. Islam—Essence, genius, nature.
3. Islamic literature—History and criticism. 4. Art, Islamic. I. Title.
BP174.P67 2008
297.5—dc22

 2008014938

Manufactured in the United States of America

On the cover: (*Top left*) In New Delhi, India, a shopkeeper arranges feni, which are sweet confections often enjoyed when the fast of Ramadan is broken each evening throughout the holy month. During each day of the month of Ramadan, a fast is observed during the daylight hours to commemorate the month during which Muhammad first began to receive God's revelations through the angel Gabriel. (*Bottom right*) A Derviche man dances among a crowd.

CONTENTS

Introduction 4

Chapter 1 Religious Practices of Islam 7

Chapter 2 Ceremonies and Celebrations 21

Chapter 3 Expressing Faith Through Fine Art 33

Chapter 4 Islamic Literature Past and Present 44

Glossary 54

For More Information 56

For Further Reading 59

Bibliography 61

Index 62

Introduction

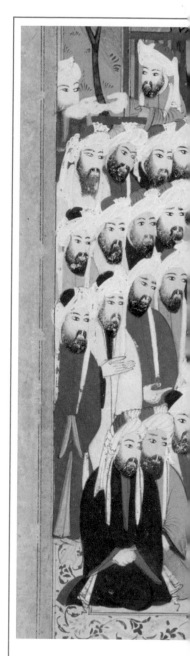

According to Islamic tradition, in the early seventh century God first revealed his message to the prophet Muhammad through the angel Gabriel. God then continued revealing scripture over a period of twenty-two years until Muhammad's death in 632 CE. Following each of Gabriel's visitations, Muhammad recited the revelations, known as the Qur'an to his followers, who memorized and drew guidance from them. After Muhammad's death, the collectively memorized revelations were set down in book form to help ensure preservation in the coming years.

Muslims do not consider Muhammad the founder of Islam. Rather, they view him as the last prophet of a long line of religious teachers going back in time to the Creation, many of whom are mentioned in the Bible and revered in the Christian and Jewish faiths. Islam teaches that Muhammad carried on

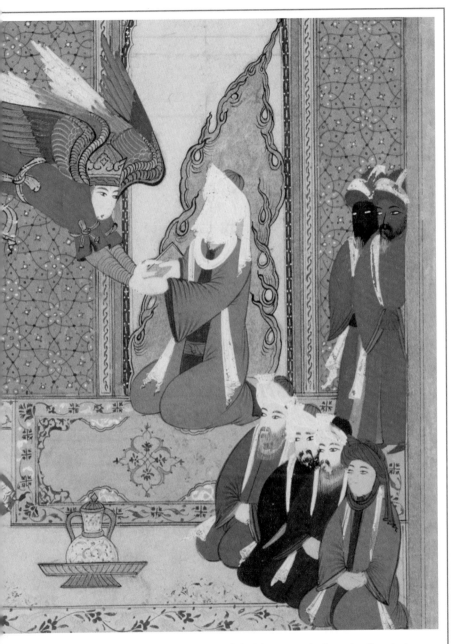

In this medieval illustration, the angel Gabriel appears before the Prophet Muhammad, revealing verses of the Qur'an.

the traditions of earlier religious figures who had submitted to the will of God, including Noah, Abraham, Moses, and Jesus. From a Muslim standpoint, the prophecies of earlier times would finally be fulfilled, and Arabs, Jews, and Christians would be united under one faith.

However, the Christians and Jews of his time, having long-established religious traditions and doctrines of their own, rejected the idea of Muhammad as the final prophet, and Islam developed as a separate religion.

Muhammad and his followers were forced to flee from the city of Mecca to Medina, under pressure by the pagans of Mecca. In Medina, Muhammad was able to establish a permanent, unified Muslim community that would eventually become strong enough to control all of Arabia. After Muhammad's death, his followers created a large empire that would eventually reach across the Middle East, into India, through North Africa, and into Spain.

In the course of fourteen centuries, Islam has spread from Medina, in present-day Saudi Arabia, to much of Africa, across Asia, through Europe, to Australia, and to North and South America. Today, there are more than 1.2 billion Muslims in the world, living as citizens in virtually every country. Even in the wake of this enormous growth, many of the practices established by Muhammad remain intact today.

Religious Practices of Islam

Islam is more than a religious or spiritual discipline. It is more than a collection of rules, prayers, or rituals. In fact, it guides all aspects of a person's life, whether at home or in public. Muslims seek to worship and obey Allah (God) in all their actions. Muslims may be guided by the words of the Qur'an, Islam's holy book, Muhammad's life example (*Sunnah*), as well as by the teachings of respected religious scholars.

The Sunnis and the Shia

Today, an estimated 85 percent of all Muslims are Sunnis, while the majority of the rest are mainly Shias. These two sects date to the earliest days of Islam. Following Muhammad's death, the Muslim community faced a crisis as his followers wondered who would lead them. The community leaders in Medina elected Muhammad's friend Abu Bakr to the position of caliph, the first of a series of four elected leaders who stuck so closely to the practices established

by Muhammad that their reigns came to be known as the period of the Rightly Guided Caliphs.

However, some members of the early community felt that Muhammad's son-in-law Ali ibn Abi Talib felt that he should have been chosen caliph, rather than Abu Bakr. Ali was eventually elected to be the fourth caliph in 656, but his rival Mu'awiya of the Umayya clan, challenged his authority and later established the Umayyad dynasty.

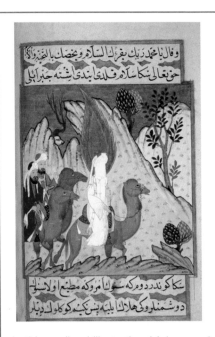

In this medieval illustration, Muhammad travels with his trusted companions Ali and Abu Bakr. Abu Bakr later became the first caliph, ruling the Muslims after Muhammad's death.

When Ali's son Hussain tried to vie for the caliphate, Yazid, Mu'awiya's son and successor, ordered his army to attack him in the area of Karbala, located in southern Iraq. While other Muslims accepted the political authority of the Umayyads and subsequent dynasties, the Shia continued to support the descendents of Ali and Hussain, known as imams, as the legitimate leaders. Shias believe that only a descendent of the prophet Muhammad has a right to rule, and that this birthright is enough to guarantee the right to rule and that elections are therefore unnecessary. Their belief emphasizes the special status of the *Ahlul Bayt*, or "People of the House," referring to Muhammad's household.

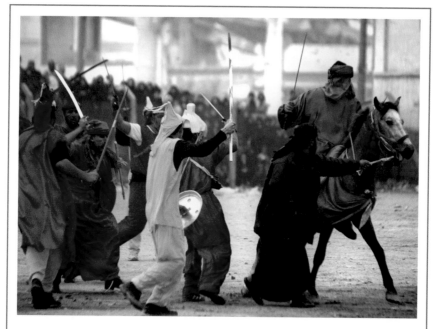

Every year, Shiite Muslims commemorate the death of Muhammad's grandson Hussain at the hands of the Umayyad caliph Yazid through a ceremony called Ashura. Reenactments are often part of the ritual.

In general, Muslims who are not Shia are called Sunnis. They follow the doctrines produced by early religious scholars that emphasized tradition and example set forth by Muhammad and his early followers as the basis for correct beliefs and practices. Sunnis believe that no Muslim has an inherent special status, and that any righteous Muslim may be elected to govern. While there are differences among members of the Sunni community, they agree on this major point.

The Shia continued opposing the Umayyads and their successors, the Abbasids. By the eighth century, they had begun developing their own traditions and compiling their

own books of Qur'anic interpretations and hadiths, or sayings of the Prophet. The Shia also developed a clerical hierarchy to guide the community, consisting of men with titles such as Ayatullah, Mullah, and Hojat-ul-Islam. These authorities emphasized the teachings of the line of infallible imams as a source for Islamic practice. Sunni Muslims do not have such a defined structure or concept of infallibility, and the term "imam" is used in a more general way to refer to respected religious scholars and leaders. The Shia also differ in some of their religious practices. For example, most Muslims pray five times each day, but Shias typically combine certain prayers and pray only three times a day. Shia Muslims also observe additional holy days, commemorating events in the lives of Ali and his descendents. Today, Shias are a large majority in Iran, and therefore Iran is the only country predominantly governed by Shias.

The Sufi Way

Sufism is a form of Islamic practice that emphasizes a mystical spirituality. Sufis seek to use their religious beliefs to attain a state of inner ecstasy, reflecting a sense of nearness to God, through religious practices that have evolved over hundreds of years. They believe that deep faith and communication with the divine can be vividly experienced through meditation, chanting, self-denial, and selfless love of others. Sufis feel that worldly possessions can corrupt the soul, so they value frugality. They learn to be patient and rely upon God's wisdom, while attaining knowledge through studies of the Qur'an, hadiths, and the writings of

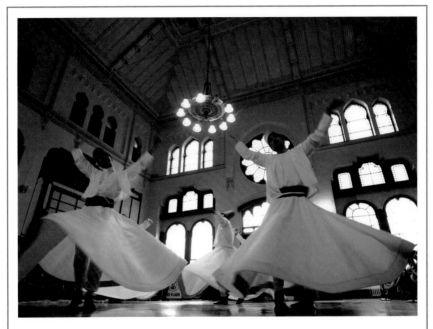

Sufi dancers perform a sema ceremony in Istanbul, Turkey. Though these dancers are performing a whirling dance, not all sema rituals call for whirling.

great Sufi masters. Often, they express the joy they derive from their faith through music and poetry. Most famous are the whirling dervishes, a Turkish Sufi group whose members spin while chanting the ninety-nine names of God in ceremonies called semas.

While there are many communities of Sufis, they are not united as a sect. Instead, they usually identify as either Sunni or Shia while following the Sufi way. For the most part, Muslims around the world acknowledge the role that Sufi approaches to Islam has played in terms of encouraging kindness, self-awareness, and wisdom.

Seven Core Beliefs and the Five Pillars

Seven core beliefs are central to the religion of Islam. These include belief in God, belief in the angels, belief in the revealed Books of God (the Qur'an, the Bible, and the Torah), and belief in God's many prophets prior to Muhammad. The Muslim must also accept that there will be a Last Day when the world comes to an end, believe in the divine measurement of human affairs, and believe in life after death.

Muhammad once told his followers that "Islam is built upon five things." Along with the seven core beliefs, these five things are the elements of religious practice that shape Islam as a faith and help guide the lives of its faithful. They are often called the Five Pillars of Islam, and they play an important role in the lives of all practicing Muslims.

Witnessing

The first and most important pillar is called the *shahadah*, or witnessing. It is a declaration that there is no deity worthy of worship but Allah (the One God) and that Muhammad is God's prophet. In the *shahadah*, a person acknowledges the supremacy of God, a recognition that will shape the rest of his or her life. He or she affirms that there is a God, and that God has made and sustains the universe, and therefore only God is deserving of worship and trust in all things.

Worship

The Second Pillar of Islam is *salah*, or worship. This is a ritual prayer that is performed five times daily, with the

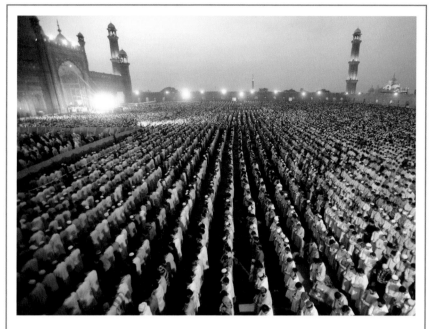

Though Muslim prayers are usually centered around a community mosque, special ceremonies may draw hundreds of thousands of worshippers to pray.

timing of each prayer tied to the natural cycle of the sun's daily course. The first of these prayers is called *fajr* and is offered at the first hint of dawn, well before the sun appears over the horizon. The second prayer is *zuhr* and is offered just after high noon. The third prayer is *asr*, the prayer of the mid-afternoon. *Maghrib*, the fourth prayer, is recited immediately after the sun sets. *Isha* is the fifth and final prayer of the day, offered when complete nighttime has arrived. Observant Muslims follow this schedule each day, taking breaks from their work or other activities to pray within allowed windows of time.

Prayer in Islam has specific rules and a set of motions designed to engage the worshipper's mind, body, heart, and spirit. Islamic prayers are designed to make the believer mindful of God's presence and to demonstrate his or her surrender to that presence. Because the Prophet encouraged worshipping as a community, Muslims worship with others in a mosque whenever possible. Otherwise, prayers may be offered alone and in almost any location. All the worshipper needs is a clean and undisturbed area to establish a sacred space for praying. A prayer carpet is not required, but many Muslims keep them handy to ensure a clean prayer space.

The worshipper must also be clean as he or she approaches God through prayer. Muslims ritually cleanse themselves, in a process called *wudu*, before offering their prayers. They wash their hands, their faces, and their arms up to the elbows, wipe their fingers over the hair on their head, and end by washing their feet up to the ankles. Each part is washed three times with cool water. If water is not available, then placing one's palms momentarily on clean sand or a stone can be a symbolic substitute for washing. These acts help Muslims prepare for their moments of worship before God.

Each of the five prayers has a specific number of bowing and prostration cycles. The dawn prayer has two cycles. The noon, mid-afternoon, and night prayers have four cycles. The sunset prayer consists of three cycles. The worshipper faces toward the Ka'bah, located in the Saudi Arabian city of Mecca, and begins the prayer by raising his or her hands to the side of the head, and saying, "God is greater," in Arabic. While standing, worshippers recite the

first chapter of the Qur'an, the Fatiha, and some verses of their own choice. Then, they bow forward and recite, "Glory be to my Sustainer, the Almighty," three times. They stand up again, saying, "God hears those who praise Him." Worshippers then prostrate themselves, touching their foreheads to the ground and saying, "Glory be to my Sustainer, the Most High," three times. They then move into a kneeling position before prostrating themselves again and repeating, "Glory be to my Sustainer, the Most High." For Muslims, bowing to the Creator is an important part of worship.

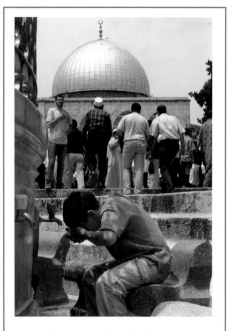

A Muslim boy washes his face before praying at the Dome of the Rock mosque in Jerusalem. The famous Muslim holy site still features outdoor fountains, where the faithful cleanse themselves before praying.

On Fridays, the noon prayer is replaced by a special congregational prayer, much like a Sunday service in a Christian church. The Friday prayer consists of two cycles. Before the prayer begins, one of the congregation's leaders delivers a sermon to the assembled worshippers.

Fasting

Fasting is the Third Pillar of Islam. Islam's annual fast period takes place during the month of Ramadan, the ninth month of the Islamic calendar. According to tradition, the first

revelation to Muhammad in the Cave of Hira took place on the twenty-seventh day of Ramadan, giving this month special significance. For the entire month of Ramadan, Muslims abstain from all food and drink, including water, from dawn until sunset each day. Each evening, Muslims break their fast with dates and milk and eat dinner before going to the mosque for special night prayers. Fasting also takes place on some holidays, but Ramadan is the principal fast.

Charity

The concept of *zakat*, or charity, forms Islam's Fourth Pillar.

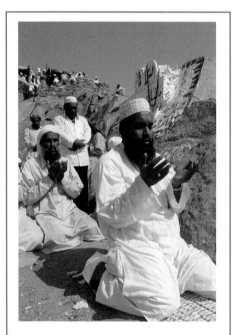

Muslims must give a portion of their wealth to the poor, usually calculated at 2.5 percent of any wealth that has gone unused for one year. The word *zakah* itself means "purification," and the practice is intended to ensure that the Muslim community looks after its less well-off.

Before beginning the hajj, pilgrims pray near the Cave of Hira, where the Archangel Gabriel first appeared to Muhammad, outside the city of Mecca.

Pilgrimage

Islam's Fifth Pillar is the hajj, a pilgrimage to the holy city of Mecca. All able-bodied Muslims who can afford the journey are encouraged to make this pilgrimage at least once in their lives. Each year, approximately two million Muslims make the

Compiling the Qur'an

Muhammad lived in an oral culture and encouraged his followers to memorize as much of the Qur'an as possible. Muhammad himself could not write, but some of his literate followers wrote down large portions of the scripture. Because paper was unknown in Arabia at the time, they used parchment, leather scrolls, and even camel bones to record the words that God delivered through Gabriel and Muhammad. Muhammad simply kept these copies of God's messages in a large bag, seeing no need to collect them into a book.

It was not until the rule of the first caliph, Abu Bakr, that the Qur'an was compiled into a book, with the chapters written in sequence on uniform parchment. By compiling the book, Abu Bakr guaranteed that the proper order of God's sayings and messages would remain just as Muhammad received them from Gabriel.

As Muslims settled beyond Arabia and spread the religion of Islam to new areas, non-Arab converts who struggled with the pronunciation of the scripture wrote the text with their own phonetic preferences, producing error-filled personal copies of the book. The third caliph, Uthman ibn Affan, ordered scribes to make copies of the official Qur'an compiled under Abu Bakr and send copies to every major city to serve as the standard reference. He also ordered all prior personal copies destroyed. In this way, the Qur'an remained a true recording of Muhammad's words.

pilgrimage. The hajj reenacts events involving the prophet Abraham, his wife, Hagar, and their newborn son, Ishmael, described in both the Hebrew Bible and the Qur'an. God tested Abraham by first asking him to abandon Hagar and Ishmael in the desert and then calling for Abraham to offer his son as a sacrifice. God stopped Abraham before he could go through with the act of sacrificing his son. Abraham's family was safeguarded when he let go of his misgivings and tried to carry out God's orders.

Islam in Daily Life

Along with the Five Pillars, the Qur'an also offers instructions on aspects of daily life. In the ideal Muslim home, husbands and wives work as equal partners. The husband is considered the protector of the family, while the wife supports him and the children are respectful and obedient to both. Parents are responsible for teaching children manners, religious practices, and about the world in general.

In the home, children will learn the basic teachings of Islam, how to read the Qur'an in Arabic, and how to be a responsible and compassionate person. In weekend schools, they may learn about the Islamic scholarly tradition and the outlines of the sharia, or Islamic law, which classifies actions according to their merit or their sinfulness. Permitted activities are called halal, while forbidden actions are haram.

The sharia includes teachings regarding which foods are permissible and which are not, meaning Muslims watch what they eat to avoid committing a sin. Pork products, animals with fangs, blood, carrion, and intoxicants such as

alcohol and drugs are considered unclean or harmful, and therefore are strictly forbidden. Permissible meat such as beef, lamb, or chicken should be slaughtered and blessed in God's name according to certain rules called *zabiha*. They can also be blessed in God's name by a rabbi according to Jewish kosher guidelines. Most Muslims eat all types of seafood, though some avoid shellfish.

Muhammad declared anything that intoxicates to be haram, including beverages such as wine or beer. A hadith (saying of Muhammad) states that anyone who buys, sells, bottles, transports, or serves alcohol is as guilty as the consumer and is cursed by God. This rule extends even to containers specifically made for holding alcoholic drinks, including wine glasses and decanters. Observant Muslims thus refrain from drinking such beverages and prefer fruit juices or soft drinks. They consider this restriction to be part of God's test of human commitment to His commandments.

Islam also forbids gambling and games of chance. They are considered tricks of the devil to distract people from serving God. While gambling is considered sinful, games that require skill are allowed so long as no betting takes place.

While Muslim scholars are unanimous on the issue of gambling, there is considerable debate around the subject of music. According to some hadiths, Muhammad forbade public dancing and solo performances by female singers. He also criticized certain instruments such as flutes and string instruments, stating that they could lead people to become lost in their passions and whims. Drums and percussion instruments are allowed, as are group singers. So long as music is not provocative or immoral according to

Islam's standards, it is generally allowed. Music has been an important part of many Muslim cultures throughout history.

In most Muslim majority countries, long-standing teachings of Islam, embodied in the sharia, serve as a basis for living in a way that pleases God and as a foundation for laws. In many countries, these teachings inform commonly held public norms and secular lawmaking, while in some nations political leaders, with the involvement of religious authorities, seek to implement generally strict interpretations found in the body of sharia literature produced over the centuries. They may have laws forbidding certain kinds of movies and music, for example. In some countries, strict limits may be placed on how women may dress and interact with men who aren't kin. In highly patriarchal (male-dominated) societies, the law may even prevent them from having the same rights as men, placing them under the guardianship of their husbands or male relatives. These nations are often criticized in the West for treating women as second-class citizens.

Many Muslims within these traditional societies and around the world often oppose such conservative inter-pretations of the sharia, seeing them as inappropriate for modern times. Most Muslims stress the need for scholars to view the sharia in dynamic terms for the ongoing reform and improvement of Muslim societies in accordance with Islamic ideals.

According to the prophet Muhammad's specific pronouncement, there are only two official holidays in Islam: a celebration marking the end of Ramadan and another celebration following the hajj. However, this does not mean that Islam lacks special observances. Some, such as Ramadan or the hajj, require a great deal of willpower and devotion. Other observances serve to mark milestones in a Muslim's life and allow the Muslim community to come together in joyous celebration.

Ceremonies and Celebrations

Ramadan

To Muslims, the month of Ramadan—the ninth month of the Muslim calendar—is the most important period of the year. Ramadan begins at the first sighting of the new moon. Muslims gather and pray before committing themselves to fasting throughout the month. During each day of the month, Muslims must refrain from eating and drinking from dawn until dusk. Only the very young, the permanently ill, elderly people who are too weak, and mentally challenged people

The Muslim Calendar

In modern times, people all over the world use the Gregorian calendar to organize activities around the 365-day solar year. For religious purposes, Muslims use a lunar, or *hijri*, calendar, which is comprised of 354 days. This calendar's dating starts from the time Muhammad traveled from Mecca to Medina (in year 622 CE of the Gregorian calendar). Because the lunar year—counted by phases of the moon—is shorter than the solar year by about eleven days, the lunar calendar shifts earlier from year to year in relation to the seasons. This can some-times affect religious celebrations. Each year, Ramadan and holidays such as *Eid ul-Fitr* fall about eleven days earlier than the previous year in the Gregorian calendar. Thus, over a span of years, Ramadan falls within every season. In winter, the daily Ramadan fast will be comparatively shorter than the longer fast on a summer day.

are allowed to skip the fast. Women in labor or who have just given birth may be given a temporary exemption as well.

The fast of Ramadan is a way to remind the faithful of God's constant presence, a means for Muslims to rise above the demands of the physical body and demonstrate the power of their belief. Faithful Muslims resolve to complete the fast because the Qur'an describes fasting as a religious duty, making it a sin to neglect the fast of Ramadan.

During Ramadan, many Muslims take a small meal called a *sahoor* before dawn. This pre-dawn meal must end at the first hint of light in the sky, meaning Muslims must wake up very early in order to eat before the day's fast begins. When the *sahoor* ends, it is time for the morning prayer, *fajr*. The fasting Muslim must then make it through the rest of the day—whether at work, at school, or at home—without breaking the fast. Along with food and drink, all actions that are normally considered undesirable—such as fighting, gossiping, cursing, and lying—are strictly forbidden. While a conscientious Muslim avoids

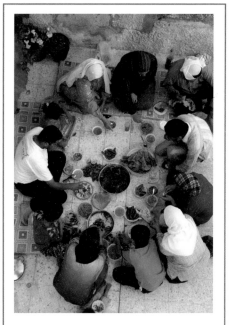

A Muslim family breaks its fast at the end of the day during Ramadan. The daily fast breaking takes place just before the evening prayer and is a time for bonding with loved ones.

these actions anyway, during Ramadan they could actually cancel out the act of fasting in the eyes of God. On the other hand, doing good deeds during Ramadan weighs more heavily in the eyes of God than at other times of the year.

The day's fasting ends when the sun has sunk completely below the horizon. Muslims may then break their fast by eating a small meal with their families called an *iftar* before praying the sunset prayer, *maghrib*. When the prayer ends, the end of the day is celebrated with a larger meal at home or in the mosque.

After the last scheduled prayer of the day, Muslims may return to the mosque to pray a special Ramadan prayer called *Salat al-Tarawih*. Each night, the imam stands in prayer with other worshippers to read one-thirtieth of the Qur'an aloud until the month ends and the reading is complete.

The Festival of Fast Breaking

When Ramadan ends, a celebration called *Eid ul-Fitr*—the Festival of Fast Breaking—begins. The festival lasts for several days and is a time for joy and giving. It starts with a sermon and a prayer called the *Eid* prayer. Afterward, Muslims celebrate their accomplishment in completing the Ramadan fast with family outings, dinners, carnivals, and parties. Many exchange cards and give gifts, particularly to children. Muslims are expected to give a small donation called *Sadaqat ul-Fitr* (Charity of the Fast Breaking) to their mosque before the end of Ramadan. This money is then used to set up meals for the poor during *Eid ul-Fitr* so that everyone can celebrate the end of the fast.

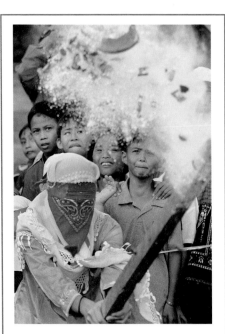

Muslims all over the world celebrate *Eid ul-Fitr* with festivals and games. Here, children in the Philippines try to break open a clay pot filled with candy and powder while blindfolded.

The Hajj

While Muslims take part in the fast of Ramadan every year, the hajj is usually a once-in-a-lifetime

undertaking. The trip to Mecca can be quite expensive, and many Muslims save up for many years to afford the journey. They also hold fund-raisers to help others make the pilgrimage. Those who do make the journey endure heat, crowds, and a series of rituals and special restrictions for the duration of the pilgrimage. But if they carry out the pilgrimage, according to a hadith, then they are granted complete forgiveness for all of their previous sins.

The hajj must take place during the beginning of the Islamic month Dhul-Hijjah. The hajj officially begins when the pilgrim arrives at a fixed entry point just outside Mecca. There, pilgrims bathe and declare their intention to make the hajj. They enter the city and make their way to a huge building called the Masjid al-Haram, which surrounds the city's holy places.

Of these various sites, the Kaaba is the holiest. This brick shrine stands in an open courtyard at the center of the Masjid al-Haram, near the spot where, according to the Qur'an, God ordered Abraham to leave his wife, Hagar, and their son, Ishmael, before going on a journey. When their food and water ran out, Hagar prayed to God for help. God heard her plea, and a spring gushed forth at Ishmael's feet. This water source became the Well of Zamzam, still flowing today. According to tradition, some years later, Abraham and Ishmael followed God's instructions and built the Ka'bah—a simple cube—at the site, which became the hub of the town Mecca. The Kaaba is kept covered in a heavy black cloth called the *kiswah*, which is embroidered with verses from the Qur'an.

During the hajj, as they journey toward Mecca, pilgrims chant a Qur'an passage over and over, which translates as:

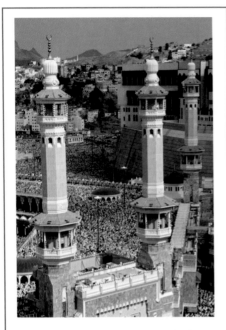

Every year, about two million Muslims journey to Mecca to perform the hajj. Here, pilgrims gather at the Kaaba for the *Tawaf* ritual.

"Here I am at Your service, O God, here I am at Your service. There is no partner with You. Here I am at Your service. All praise and all blessings belong to You. All dominion is Yours, and You have no partner." When they reach the Kaaba, the pilgrims walk around it seven times, pointing toward it and repeating the chant. This ritual is called the *Tawaf*, or Encircling.

When they finish the *Tawaf*, pilgrims go to the actual Well of Zamzam and drink its water. They follow a walkway back and forth between two hills, following Hagar's frantic search for food and water. The rest of this first day of the hajj is spent in prayer and contemplation.

On the second day of the hajj, pilgrims meet in a valley called Mina, where they spend the day praising God. They spend the night in tents before moving on the next morning to a barren plain called the Plain of Arafah. The plain, exposed to the baking sun, represents what the world will be like on the day of judgment, when God decides who is worthy of entering heaven. Pilgrims remain there in prayer all day, then travel to a place called Muzdalifah, where they set up tents for the night.

The next morning, they return to Mina and gather around several stone pillars. They throw pebbles at these pillars in a symbolic stoning of the devil, who tried to talk Abraham out of sacrificing his son. This ritual symbolizes Abraham's rejection of Satan and the will of the pilgrims to always reject temptation and obey God.

Next, the pilgrims reenact Abraham's sacrifice. God's purpose in asking him to sacrifice his son was to test him, to see if Abraham loved God above all else. Ultimately, God spared Abraham's son and an animal was sacrificed instead. The pilgrims themselves sacrifice animals as part of the hajj, usually goats, cows, camels, or sheep. Each group of five or ten people sacrifices one animal according to the rules of *zabiha*: the knife has to be very sharp, and the kill can only be made with a single swift cut across the jugular vein to minimize the animal's pain. By making the sacrifice, pilgrims show God their willingness to obey holy commands, as Abraham was willing to sacrifice his son. The meat from the sacrifices is later used to feed the pilgrims, and a great deal of it is fed to the poor.

After the sacrifice, male pilgrims shave off their hair to symbolize their rebirth into faith. Women cut a lock of their hair to symbolize this same transition. The pilgrims are then released from the hajj restrictions. On the day after the hajj ends, the holiday called *Eid ul-Adha*—Festival of the Sacrifice—begins. Pilgrims who made the hajj congratulate each other and reflect on their life-changing experience during this three-day festival, which is observed in ways very similar to the annual *Eid ul-Fitr* celebrations.

Festivals, picnics, and parties are also part of the celebration, and returning pilgrims are welcomed with special dinners and programs in their honor.

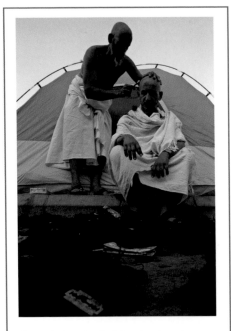

Completing the hajj is a landmark event in a Muslim's life. Male pilgrims have their heads shaved to help mark their spiritual rebirth.

Other Important Celebrations

Islamic tradition does not call for the celebration of birthdays, but many Muslims make an exception for *Milad un Nabi*, the day the prophet Muhammad was born. This unofficial holiday takes place in the Islamic month of Rabiul-Awwal. Muslims observe the day by singing songs, reciting poetry, giving speeches, and even holding conferences to praise the Prophet's life and virtues. Some Muslims, however, object to the holiday. They believe that by celebrating Muhammad's birthday, they would be placing more importance on the man than on the message of God that was delivered through him. Even so, Muhammad's birthday is honored in a majority of Muslim cultures around the world.

Landmark Events

Islam recognizes three specific ceremonies relating to the major turning points of human life: marriage, births, and funerals. In Islamic culture, the customs for these events

were first established by the prophet Muhammad, who personally conducted the appropriate ceremonies within the early Muslim community. By carrying out these ceremonies, today's Muslims not only connect with other members of their own community but also with Islam's rich traditions.

Nikah means marriage in Islam. Because dating is not allowed in Islam, a series of customs have evolved to help prospective married couples meet. Potential matches are often arranged by relatives, professional matchmakers, or through contacts made at social gatherings or at school. Unmarried men and women are not allowed to be alone together, so they must have chaperones present. Previously unmarried young women who are seeking husbands are required to have a guardian, called a *wali*, who acts on their behalf. The *wali* will help set up meetings with potential husbands, while also keeping undesirable men away. Although the *wali* may represent the bride's interests, the bride and groom have the sole right to consent to marriage or decline a marriage proposal.

If a chaperoned meeting goes well, then the couple may continue getting to know each other through subsequent meetings for as long as they like. If they decide to get married, then a public announcement of their engagement is made and a wedding date is set. The woman then sets a dowry, called a *mahr*, or marriage gift, that her bridegroom must pay. The *mahr* is traditionally meant to show the groom's seriousness regarding marriage and to ensure that the bride will have some financial security in case the marriage ends.

Marriages generally take place either in a mosque or in a public hall. The couple sits at the front, facing the

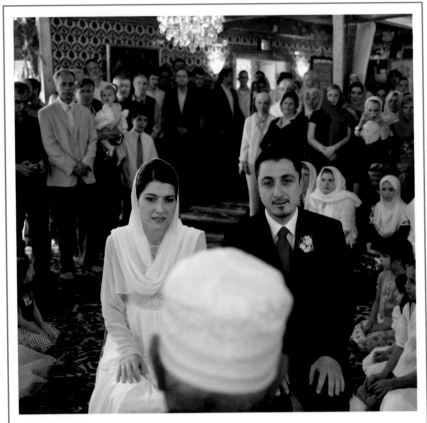

Muslim weddings follow the traditions established during Muhammad's lifetime. They also may include modern traditions, such as the inclusion of bridesmaids in the ceremony.

imam, who asks the *wali* if the woman has agreed to the marriage. He then asks the bridegroom if he agrees and announces that the *mahr* has been agreed upon and other conditions met. Both parties then exchange and sign a wedding contract specifying the rights, duties, and obligations each side wants the other to obey. The imam reads the

sermon of marriage and the opening of chapter four of the Qur'an, which tells the story of God's creation of men and women. He announces that the marriage is complete, and the audience responds by congratulating the newlyweds. A reception called a *walima*, hosted by the groom's family, follows, featuring food, games, and gifts.

Muslims mark the birth of a baby through a ritual called the *Aqiqah*, or Welcoming Consecration, which usually takes place seven days after birth, though the preliminaries begin immediately after birth. When the baby is first delivered, typically the father whispers the Muslim call to prayer into the infant's ear. This is followed by a prayer and, in some cultures, the act of rubbing a date onto the baby's gums, a custom intended to bring the infant good fortune in life. The parents then select a name for the child, one that reflects Islamic values. Many boys are named after prophets or their companions, while girls are often named for members of the Prophet's household or terms from the Qur'an. Other names feature noble traits for boys and names of flowers and elements of nature for girls.

The actual *Aqiqah* ceremony happens seven days after birth. The family gathers for a special dinner of sheep or goat, the animal having been ritually sacrificed earlier in the day. A portion of this meat is also given to the poor. The baby's hair is shaved off and weighed. The parents then give its weight in silver to charity while people congratulate them and offer gifts for the baby.

Muslims consider death a doorway into the third stage of life. It is the time spent in the grave prior to judgment

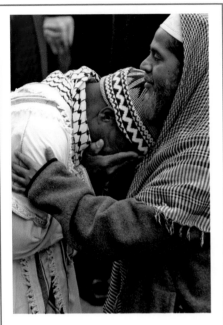

Funerals give Muslim communities an opportunity to come together and heal following a tragedy. Even after the ritual, friends and neighbors continue offering support to mourners.

day. Islamic law says that a body is supposed to be buried within three days of death, and funerals often take place as quickly as possible. The body is carefully washed, wrapped in white sheets, and placed in a coffin. Usually, it is taken to a mosque for a special funeral prayer called the *Janazah*. Friends and relatives line up in rows with the coffin in front of them and conduct the entire prayer standing up, reciting the words of the prayer silently to themselves and asking God to forgive the deceased for any sins. While mourners are permitted to cry and show sorrow, loud wailing and tearing of clothes are not allowed. Mourners then take the body to the graveyard, placing it in the grave as verses of the Qur'an are read. For several days after the funeral, people visit the deceased's survivors, bringing food and comforting them.

In the centuries since Muhammad's death, artists have found countless ways to express their faith or depict daily life in the various Muslim cultures. Distinct forms of architecture developed during the golden age of Islamic civilization, as did elaborate forms of artistic design. Despite the Prophet's restrictions on certain instruments, music also flourished.

Expressing Faith Through Fine Art

Art Forms

Islam prohibits paintings or drawings of people and animals that appear too lifelike. Realistic painting and drawing risk creating idols that may lead worshippers astray. However, this does not mean that art is forbidden. Many Muslim artists turn to art forms that use geometric forms, the Arabic language, and shapes from nature, especially in objects used in religious settings. These forms are used to glorify God and the message of the Qur'an, which are seen as more worthy than other subjects.

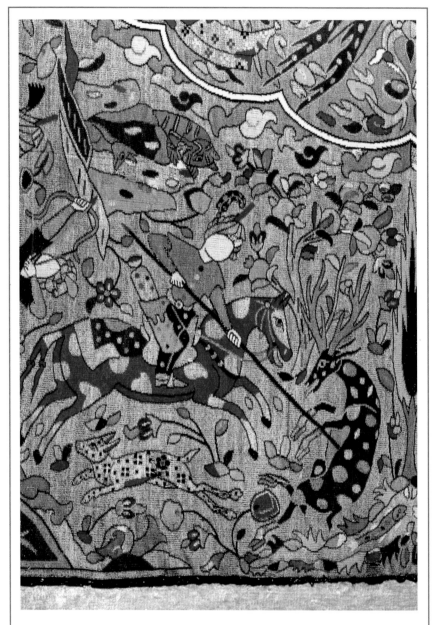

The faces of the hunters in this seventeenth-century Persian rug were likely left blank by the artist in order to avoid creating lifelike human forms.

Historically, Muslim artists have painted human and animal figures on household objects or pieces that did not have any religious significance. Sometimes, they use unnatural coloring to make it clear that the art is not meant as a "creation" of life. For the same reason, artists also avoid depicting character or emotion in their work. Persian miniatures are small paintings that depict a variety of scenes, from kings out hunting to peasants going about their daily lives. Mythological creatures are another popular subject. Many of these vivid paintings serve as illustrations for folktales and stories, poetry, and other books. The art form was born during the Middle Ages, and it spread throughout the Muslim lands during the fifteenth and sixteenth centuries. Today, Muslims continue to avoid highly representational images and objects, though photography is now a widely accepted art form.

Arabesques are combinations of shapes and floral designs that repeat endlessly to form intricate patterns. To Muslims, they symbolize the complex and ever-present nature of God. Arabesques originated in the ninth century and quickly became a popular element in Muslim art and architecture. Arabesques often decorate the walls of mosques, palaces, and other public buildings designed by Muslims or influenced by Islamic architecture.

Calligraphy is the artistic writing of Arabic script. Muslim calligraphers often use the words of the Qur'an as subject matter, writing verses with a visual flourish meant to emphasize the beauty of the words for the believer. The work of calligraphers may be done in many styles,

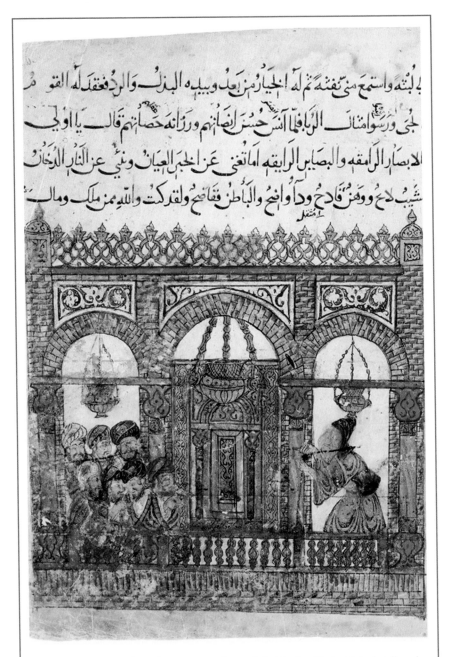

Persian miniatures often show scenes from daily Muslim life in high detail and vivid colors. This example dates from 1208 and shows the interior of a mosque.

from simple pen-and-ink renderings to elaborate designs produced with the latest computer graphics software. Calligraphy is a common decorative design element in Muslim homes.

Mosque Architecture

Mosque architecture is often seen as one of the highest achievements and noblest expressions of Muslim art. All mosques share some common elements. The *qibla* wall is the wall of the mosque that faces Mecca and marks the direction in which Muslims should pray. The *qibla* wall is marked by an empty niche called a *mihrab*, often made of carved stone. The *minbar*, or pulpit, faces the congregation and is used for giving the Friday sermon. A raised platform called a *maqsura* is reserved for Qur'an reciters or worshippers who, during prayer, repeat the words of the imam for attendees who are farther away from the pulpit. In early mosques, a fountain was often located in the center of the courtyard for ablutions (ritual washing) before prayer. Today, modern plumbing with numerous faucets has largely replaced that tradition.

Mosques may be built from many materials, though stone and concrete are probably the most commonly used. Their exteriors are often heavily ornamented with geometric patterns and calligraphy, though the interior may be more muted. Minarets—towers from which the call for prayer is announced five times a day—are often a mosque's most distinct feature. These slender towers can be in many styles, from fairly simple to extremely ornate. They consist of a base, the shaft containing the stairs, and the gallery,

The Taj Mahal

The Taj Mahal was built in Agra, India, by the Mughal emperor Shah Jahan—a Muslim ruler—to commemorate the death of his beloved wife, Mumtaz Mahal. The elaborate tomb and its complex of buildings and gardens took roughly twenty-two years to complete. At least twenty-thousand laborers from northern India helped in the construction. The main structure, which includes the tomb's famous white dome, was completed in 1643, though other elements were finished later.

The Taj Mahal's design incorporates many elements of Muslim art and architecture, from its four minarets to the calligraphy adorning its outer walls. The tomb's onion dome—so called because of its shape—rises above a multichambered structure built to exacting symmetry. The dome itself is topped by a finial featuring a crescent moon, a popular design feature in Muslim architecture.

The Taj Mahal fell into disrepair during the mid-nineteenth century, when Great Britain ruled India as a colony. A massive restoration project completed in 1908 reversed much of the damage. In 1983, the Taj Mahal was named a UNESCO World Heritage Site. Today, it draws two to three million visitors each year.

The Taj Mahal's famous dome shimmers in one of the monument's reflecting pools. The crescent moon finial is visible at the dome's top.

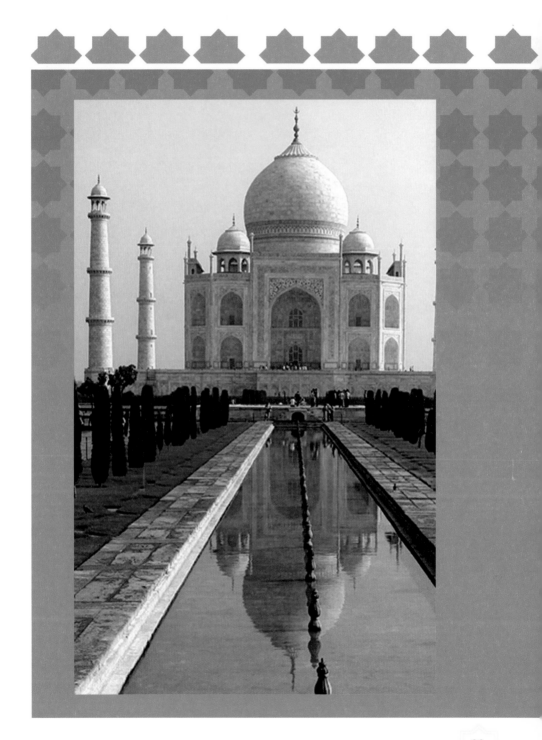

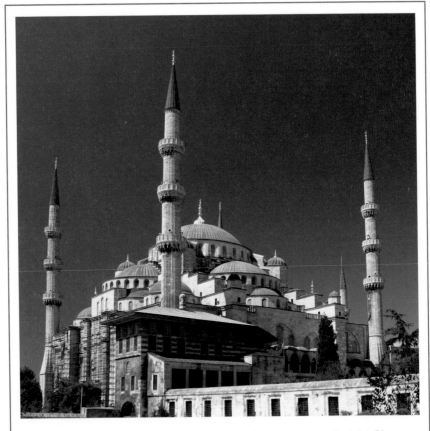

The Sultan Ahmed Mosque in Istanbul, Turkey, is commonly called the Blue Mosque for the blue tiles that decorate its interior. The mosque was built between 1609 and 1616.

where traditionally the *muezzin* calls the faithful to prayer, although in modern times loudspeakers are mounted on the minarets instead. The gallery usually has a conical or domed roof and is often the most elaborate part of the minaret. Though usually attached to mosques, minarets are sometimes seen as freestanding structures, particularly in Iran. Historically, minarets may have also served as

lighthouses or landmarks for traveling caravans approaching a walled city.

Music

While classical styles that were popular during Muhammad's lifetime are still common, music has evolved greatly in the context of Muslim cultures. Typically, wherever Muslims settled and integrated with regional cultures in early Islamic history, local instruments and musical forms were absorbed and incorporated. Despite certain scholarly opinions opposed to them, in most Muslim cultures stringed and wind instruments were among the many types of instruments used by musicians in courtly and popular settings. In modern times, musicians and artists incorporate elements of rap and hip-hop, rock, jazz, pop, and other genres into their art, reflecting a globalized mixture of styles. However, conservative or very pious Muslims still consider any instrument other than percussion and the human voice forbidden.

Contemporary groups may perform songs called *nasheed*, a type of devotional music in praise of the Prophet Muhammad that employs only percussion and the human voice. Some *nasheed* groups may bring other instruments into their performances. These could include the oud (a pear-shaped stringed instrument that is plucked like a guitar), the long-necked rebab (played with a bow, like a violin, or plucked), and the ney (an ancient form of flute with five or six finger holes that is blown from the end).

Vocal music remains very common in Muslim countries. In India and Pakistan, for example, concerts by devotional vocalists are called *qawwali*. They may include a *hamd*,

Two Iraqi men prepare to venture out to chant and play their drums, called *dammam* in Iraq, as a way to wake the faithful at the beginning of Ramadan.

a song in praise of God, and a *naat*, a song praising Muhammad. Other songs may include *manqabats* praising famous Sufi teachers, whose teachings many *qawwali* vocalists follow. *Ghazals* are songs about love and intoxication, but the singers use them to illustrate their devotion to God. The best known *qawwali* singer in recent years may have been Nusrat Fateh Ali Khan (1948–1997), whose fame spread far beyond his home in Pakistan. In his later years, he even collaborated with rock musicians such as Eddie Vedder and Peter Gabriel, while his music appeared in Hollywood movies.

Islamic Literature Past and Present

S ince the compilation of the Qur'an following the Prophet's death, literature has had a prominent role in Islamic culture. Literacy is one of the commandments of Islam, and books and poems written throughout Muslim history found a ready audience. Today, many classics of Muslim literature have crossed over and are widely read throughout the world.

One Thousand and One Nights

One Thousand and One Nights, sometimes called *The Arabian Nights*, is one of the best known works to emerge from Muslim civilization. Some elements of the stories collected in this work—such as the famous "Aladdin's Wonderful Lamp," "The Seven Voyages of Sinbad the Sailor," and "Ali Baba and the Forty Thieves"—can be traced to Middle Eastern tales predating the rise of Islam. The book is set up as the heroine, Queen Scheherazade, tells these stories over the course of 1,001 nights to her cruel husband, King Shahryar, in order to delay her own execution. Many of the Persian and Indian folktales found

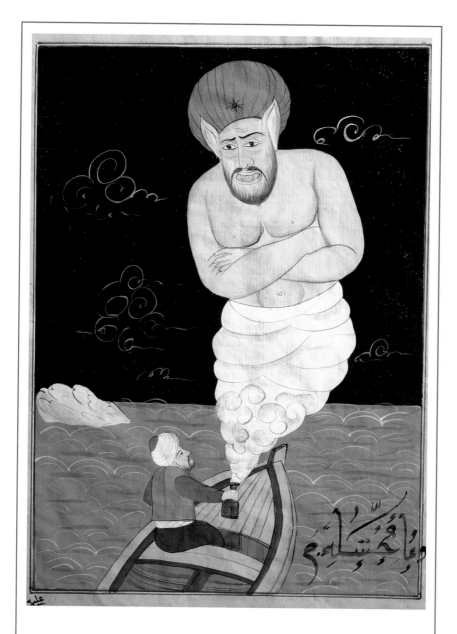

A genie appears from a lamp in the tale "Aladdin's Wonderful Lamp," one of the best-known stories from the classic *One Thousand and One Nights*.

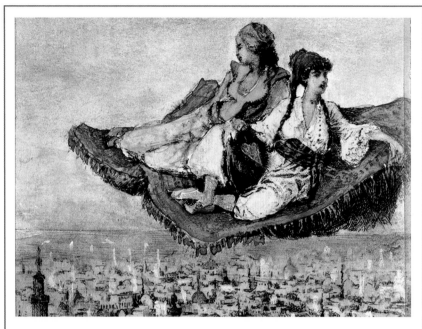

The tales in *One Thousand and One Nights* feature many elements from older Persian legends, including mythical creatures and flying carpets.

in this book end with their characters caught in suspenseful situations, and King Shahryar became so caught up in his wife's cliffhanger narrative style that he continued sparing her life in order to hear more stories and find out how they ended.

Many of the stories Scheherazade told were originally collected during the ninth century under the title *Thousand Myths*, possibly by the Persian storyteller Abu abd-Allah Muhammed el-Gahshigar. Before then, they had evolved over centuries in countless oral traditions that Muslim traders encountered on their travels through Asia. The

innovative frame of the story, in which the fictional Scheherazade cleverly spares her own life each night through her storytelling, was added sometime during the fourteenth century.

The tales have continued evolving over the centuries. They became widely known in Europe during the nineteenth century after Antoine Galland published the first translation of the tales from Arabic to French in a twelve-volume set. The famous adventurer Sir Richard Francis Burton published a popular English version in 1885. They have also inspired and influenced countless authors. These include American writer Edger Allan Poe, who wrote a short story called "The Thousand and Second Tale of Scheherazade," describing an eighth voyage by Sinbad, and the Nobel Prize–winning Egyptian author Naguib Mahfouz, whose 1981 novel *Arabian Nights and Days* was based on the tales.

Although *The Arabian Nights* is the best known, there are many other fascinating creative works and scholarly writings that make up a huge body of literature produced over fourteen centuries in Arabic, Persian, Turkish, and other languages by Muslims and others living in Muslim lands.

Poetry

Poetry was such an important part of Arab and Persian culture that even authors of scientific and mathematical works often included poetic verses to embellish their texts. Scholars in all fields were expected to know and write verse, and many poets enjoyed patronage from powerful rulers. Of the poetry that has survived since that time, the work of Omar Khayyam is among the most widely known.

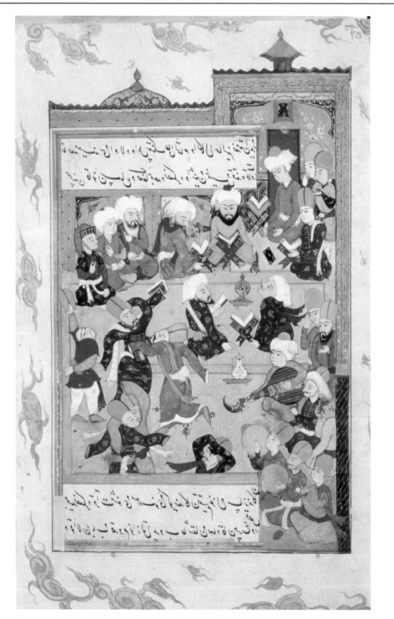

The poet and mystic Jalaluddin Rumi was one of the foremost Sufis of his time. His followers began the whirling sama dance.

Khayyam (1048-1123) was a Persian mathematician and astronomer. Though he made significant contributions in both fields, he is best known today for his four-line verses, called *rubaaiaa* (quatrains). Khayyam wrote about one thousand of these poems during his lifetime, many on themes of friendship, love, and human nature. Khayyam's religious views are not known, and the verses are vague enough that many different readings are possible. Some believe that his seemingly sensual and risque verses actually describe his relationship with God, while others take the view that the poems prove he was an atheist.

Khayyam's poetry gained a new audience when about one hundred of his verses were translated into English as *The Rubaiyat of Omar Khayyam* by Edward Fitzgerald in 1859. In the process of translating them from Persian, Fitzgerald took many liberties with the poems. More accurate translations of Khayyam's verses have since been made, but Fitzgerald's remains the most popular.

Jalaluddin Rumi's poetry has also remained popular among Muslims. Rumi (1207–1273) was a great Sufi mystic who was inspired by the disappearance of his master, the dervish Shams ad-Din, to write more than thirty thousand verses in Persian. Rumi later founded his own mystical community in the spirit of Shams ad-Din and composed his greatest work, a collection of verses called *Masnavi-I Ma'navi* ("Rhyming Couplets of Spiritual Meaning"). In them, Rumi uses drunkenness as a metaphor for the ecstasy of seeking God. Today, Rumi's poems are among the most widely read in the United States. After Rumi's death, his

followers organized themselves into a Sufi order called the *Mawlawiyah*, sometimes called the whirling dervishes.

The poetry of the Sufi Farid ud-Din Attar (1145–1221) greatly influenced Rumi and countless other poets who followed. Little is known about Attar's life, as his work didn't gain widespread renown until the fifteenth century. Attar composed long narrative poems, the most famous of which is the *Manteq al-Tayr* ("Conference of the Birds"). The poem tells the story of all the world's birds setting out on a quest to find the king of birds, Simurgh. On their journey, they must cross seven valleys, each of which teaches them to sacrifice and trust in God. Only thirty birds make it to Simurgh's home, where they learn that their quest has been swallowed up in the infinite power and wisdom of God.

Modern Writers

While poetry and stories dominated Muslim literature for hundreds of years, the twentieth century saw the rise of the novel in Muslim countries. Many authors write about the conflicts in the modern world, the place of Islam on the global scale, and personal struggles living as a Muslim under various religious (Iran, Afghanistan) and secular (Egypt, Turkey) regimes. In some cases, novelists have offended conservative Muslims by producing works deemed to be critical of Islam.

Egyptian author Naguib Mahfouz was one such writer. During his lifetime, Mahfouz published thirty-four novels and hundreds of short stories, as well as movie scripts and plays. Mahfouz is often credited with helping to modernize

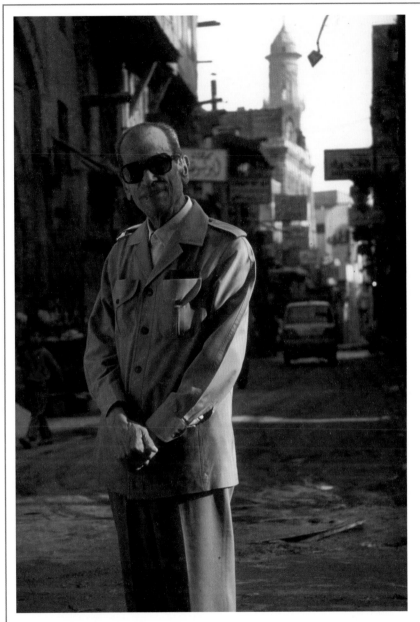

Egyptian author Naguib Mahfouz told the stories of modern-day Muslims in his many novels, short stories, and screenplays, challenging Muslim sensibilities and receiving a Nobel Peace Prize.

Persepolis

Iranian-born writer and illustrator Marjane Satrapi broke new ground with her graphic novel *Persepolis: The Story of a Childhood*. It describes growing up in Iran following that country's Islamic Revolution, when Muslim fundamentalists seized control of the government from its secular but tyrannical U. S.-backed dictator, the shah of Iran. The novel presents her family's struggle to adapt to the sudden changes using simple drawings to illustrate the story. War, oppression, and the deaths of loved ones are all addressed. Life under the new regime was often as brutal, in its own way, as the one that preceded it.

Satrapi published *Persepolis 2: The Story of a Return*, in 2005, documenting her sometimes rocky readjustment to life in Iran after years spent living in Germany. Both books were widely praised. *Persepolis* was made into an animated movie in 2007.

Satrapi and director Vincent Paronnaud win the Grand Jury Prize for *Persepolis* at Cannes.

Arab literature by focusing on the present (rather than the historical golden age of the Islamic empire and the semi-legendary past of the Arabian world) and the ways in which ordinary people deal with political and cultural upheaval. In books such as *The Children of Gebelawi,* characters attempt to follow the path of their ancestors, only to find suffering. Mahfouz also took on controversial topics in Islam, such as homosexuality, the nature of God, and humanity's place in the universe. In 1988, he received the Nobel Prize for Literature for his body of work. However, due to protests by some vocal Muslim groups, some of his books were banned for a time in his native Egypt and in other Muslim countries because of alleged blasphemy or other controversial subject matter. He also received death threats from Muslim extremists and survived an assassination attempt in 1994. He died in 2006 after years of declining health. Without a doubt, Mahfouz was a pioneer and remains a source of pride for many Arabs and Muslims.

The multilayered splendor of Muslim literature, visual arts, architecture, and music is a vital and enduring testament to the creativity, artistry, and deep humanity of Muslim culture. Every aspect of this culture is connected to and inspired by the wonder, joy, richness, ritual, and moral and ethical guidance of Islam. In this sense, the acts of artistic expression and reception are, just like the observance of holy days, a celebration of God's power and presence amongst us.

GLOSSARY

caliph A Muslim political leader; the head of the Muslim community and successor to Muhammad.

dynasty A series of powerful leaders belonging to the same family.

fasting Depriving oneself of food for a set period of time, often as an act of devotion to God.

hadith Sayings of the prophet Muhammad.

halal Something permitted under Islamic law, often referring to food.

haram Something forbidden under Islamic law.

infallible Incapable of failure or error.

minaret A tower of a mosque from which the call to prayer is made.

mosque A building where faithful Muslims gather in order to pray.

muezzin The member of a Muslim community who calls other Muslims to prayer.

mystic Someone who strongly believes in states of reality outside of what humans can perceive; someone seeking a personal encounter with the Divine.

parchment A sheet of sheepskin or goatskin that has been prepared for writing on, or a particularly fine sheet of paper.

pilgrimage A journey made to a sacred place or for religious reasons.

prayer carpet A small rug, often patterned, used by
 Muslims to pray on.

prostration Placing oneself on the ground and bowing,
 often in prayer.

Shia Muslims who have always emphasized that
 Muhammad's son-in-law, Ali, and his descendents are
 the rightful successors of Muhammad and leaders of the
 Muslim community. They comprise roughly 15 percent
 of all Muslims.

Sufism A form of Islamic worship that emphasizes mysticism,
 self-denial, and cultivation of God-consciousness.

Sunni Muslims who have accepted the political leadership
 of various early caliphs and dynasties, as long as they
 upheld the Qur'an and Sunnah of Muhammad in their
 policies. They comprise more than 80 percent of all
 Muslims.

zabiha The prescribed method of slaughter, according to
 Islamic law, which ensures that a blessing acknowledging
 God is pronounced before killing a creature for food.

FOR MORE INFORMATION

Canadian Islamic Congress
675 Queen Street South, Suite 208
Kitchener, ON N2M 1A1
Canada
(519) 746-1242
Web site: http://www.canadianislamiccongress.com
This organization advocates for the rights of Muslims living within Canada.

Institute of Near Eastern and African Studies
P.O. Box 425709
Cambridge, MA 02142
(617) 864-6327
Web site: http://www.ineas.org
This is a nonprofit organization devoted to educating the public and informing the media on issues relating to the Arab and Muslim worlds, as well as Africa and the non-Muslim Middle Eastern communities.

Metropolitan Museum of Art—Islamic Art Department
1000 Fifth Avenue
New York, NY 10028
(212) 535-7710
Web site: http://www.metmuseum.org/Works_of_Art/
islamic_art

New York's Metropolitan Museum of Art has a large collection of Islamic works of art on display, some of which can be viewed online in the collection database on the museum's Web site.

Midwest Association of Shia Muslims
P. O. Box 59916
Chicago, IL 60659
(773) 283-9718
Web site: http://www.masom.com
This organization is dedicated to religious and educational activities for the large Shia community in the American Midwest.

Organization of the Islamic Conference
P.O. Box 178
Jeddah-21411, Kingdom of Saudi Arabia
Web site: http://www.oic-oci.org
The Organization of the Islamic Conference consists of fifty-six member nations. Representatives meet every year to discuss issues related to Islam and Muslim culture.

Sufi Order International
North American Secretariat
P.O. Box 480
New Lebanon, NY 12125
(518) 794-7834
Web site: http://www.sufiorder.org
The Sufi Order International focuses on educating people about the Sufi way.

Web Sites

Due to the changing nature of Internet links, Rosen Publishing has developed an online list of Web sites related to the subject of this book. This site is updated regularly. Please use this link to access this list:

http://www.rosenlinks.com/ui/icc

For Further Reading

Barnes, Trevor. *Islam: Worship, Festivals, and Ceremonies from Around the World*. New York, NY: Kingfisher Publishing, 2005.

Doak, Robin. *Empire of the Islamic World*. New York, NY: Facts On File, 2004.

Douglass, Susan L. *Ramadan* (On My Own Holidays). Minneapolis, MN: Carolrhoda Books, 2003.

Ganeri, Anita. *Muslim Festivals Throughout the Year* (A Year of Festivals Series). Mankato, MN: Smart Apple Media, 2003.

Ibrahim, Muhammad, and Anita Ganeri. *Muslim Prayer and Worship*. North Mankato, MN: Sea to Sea Publications, 2008.

Khan, Rukhsana. *Muslim Child: Understanding Islam Through Stories and Poems*. Morton Grove, IL: Albert Whitman & Company, 2002.

Lombard, Maurice. *The Golden Age of Islam*. Princeton, NJ: Markus Wiener Publishers, 2003.

MacMillan, Dianne. *Ramadan and Id al-Fitr*. Berkley Heights, NJ: Enslow Publishing, 2008.

Mahfouz, Naguib. *Arabian Nights and Days*. New York, NY: Doubleday, 1995.

Marston, Elsa. *Muhammad of Mecca: Prophet of Islam*. New York, NY: Franklin Watts, Inc., 2001.

Morris, Neil. *The Atlas of Islam: People, Daily Life and Traditions*. Hauppage, NY: Barron's Educational Series, 2003.

Ross, Mandy. *Mecca*. Chicago, IL: Raintree Press, 2003.

Satrapi, Marjane. *Persepolis*. New York, NY: Pantheon Books, 2003.

Wilkinson, Philip. *Islam*. New York, NY: DK Eyewitness Books, 2002.

BIBLIOGRAPHY

Al-Faruqi, Isma. *Cultural Atlas of Islam*. New York, NY: Collier MacMillan, 1986.

Emerick, Yahiya. *The Complete Idiot's Guide to Understanding Islam*. Indianapolis, IN: Alpha Books, 2002.

Grieve, Paul. *A Brief Guide to Islam*. New York, NY: Carroll & Graf Publishers, 2006.

Hassaballa, Hesham, and Helminski, Kabir. *The Beliefnet Guide to Islam*. New York, NY: Random House, Inc., 2006.

Hiro, Dilip. *The Essential Middle East: A Comprehensive Guide*. New York, NY: Carroll & Graf Publishers, 2003.

Lindsay, James E. *Daily Life in the Medieval Islamic World*. Westport, CT: Greenwood Press, 2005.

Peters, F. E. *The Hajj: The Muslim Pilgrimage to Mecca and the Holy Places*. Princeton, NJ: Princeton University Press, 1994.

Rippin, Andrew. *Muslims: Their Religious Beliefs and Practices*. New York, NY: Routledge, 2001.

Robinson, Francis, ed. *The Cambridge Illustrated History of the Islamic World*. New York, NY: Cambridge University Press, 1996.

Rosen, Lawrence. *The Culture of Islam: Changing Aspects of Contemporary Muslim Life*. Chicago, IL: University of Chicago Press, 2002.

INDEX

A

Abraham (prophet), 18, 25, 27
Allah, 7, 12
Arabian Nights, 44, 47
art forms, Islamic
 Arabesques, 35
 architecture, 35, 37, 38
 calligraphy, 35, 37, 38
 literature, 35, 44, 46–47, 49–50, 53
 music, 41, 43
 Persian miniatures, 35
 photography, 35
 realistic paintings/drawings, 33, 35

C

caliphs, 7–8, 17
cultural practices, Islamic,
 birthdays, 28
 births, 28, 31
 diet, 18–19
 and family, 18
 funerals, 28, 31–32
 gambling, 19
 marriage, 28–31
 music/dancing, 19–20, 41, 43
 women's rights, 20

D

dowry, 29

E

Eid ul-Adha, 27
Eid ul-Fitr, 22, 24, 27

F

fajr, 13, 23
Fatiha, 15
Five Pillars of Islam, 12–16, 18

G

Gabriel (angel), 17
Gregorian calendar, 22

H

hadiths, 10, 19, 25
Hagar, 18, 25, 26
hajj, 16, 18, 21, 24–28
halal, 18

I

imams, 10, 24, 30
India, 6, 38, 41
Ishmael, 18, 25
Islamic prayer, rules of, 14–15

J

Janazah, 32

K

Kaaba, 25–26
kosher, 19

L

lunar calendar, 22

M

maghrib, 13, 23
Masjid al-Haram, 25
Mecca, 6, 16, 25, 37
Milad un Nabi, 28
minarets, 37, 40–41
mosques, 14, 16, 23, 24, 32, 35,
 37, 40
Muhammad (prophet), 4, 6, 7–9,
 12, 16, 17, 19, 21, 22, 28, 29,
 33, 41, 43
mythological creatures, 35

O

One Thousand and One Nights, 44,
 46–47

P

Pakistan, 41, 43
patriarchal, 20
Persepolis, 52

Q

Qur'an, 4, 7, 10, 12, 15, 17, 18, 22,
 24, 25, 30, 31, 32, 33, 37, 44

R

Ramadan, 15–16, 21–24
religious practices, Islamic,
 ceremonies/celebrations, 21–32
 and cleanliness, 14, 37
 fasting, 15–16, 21–24
 Five Pillars, 12–16, 18
 and pilgrimage, 16, 18, 25–28
 seven core beliefs, 12
 Sufism/Sufis, 10–11, 43
 Sunnis/Shias, 7–10

S

Sadaquat ul-Fitr, 24
Salat al-Tarawih, 24
sharia, 18–20

T

Taj Mahal, 38
Tawaf, 26

W

Well of Zamzam, 25–26
whirling dervishes, 11

Z

zabiha, 19, 27

About the Author

Jason Porterfield has written numerous books for the Rosen Publishing Group. In his writing, he has described religious customs and practices in country studies of Sweden, Chile, Argentina, and Vietnam. Porterfield graduated from Oberlin College with a B.A. in English, religion, and history. He currently lives in Chicago.

About the Consultant

Munir Shaikh oversees research and consulting activities at the Institute on Religion and Civic Values (IRCV), a non-advocacy organization with expertise in world religions, world history, civil society, pluralism, and related subjects. Munir has a master's degree in Islamic studies from the University of California, Los Angeles, and has more than fifteen years of experience in writing and editing texts pertaining to Islamic history and culture.

Photo Credits

Cover (bottom left) Prakash Singh/AFP/Getty Images; cover (bottom right) Bruno Morandi/ The Image Works/Getty Images; pp. 4–5 Réunion des Musées Nationaux/Art Resource, NY; p. 8 The New York Public Library/Art Resource, NY; p. 9 Essam Al-Sudani/AFP/ Getty Images; p. 11 Gali Tibbon/AFP/Getty Images; p. 13 Arif Ali/ AFP/Getty Images; p. 15 Hazem Bader/AFP/Getty Images; pp. 16, 28 Muhannad Fala'ah/Getty Images; p. 23 Jaafar Ashtiyeh/AFP/ Getty Images; pp. 24, 32 © AP Images; p. 26 Abid Katib/Getty Images; p. 30 Ziyah Gafic/Reportage/Getty Images; p. 34 Werner Forman/Art Resource, NY; p. 36 Erich Lessing/Art Resource, NY; p. 39 Tauseef Mustafa/AFP/Getty Images; p. 40 Shutterstock.com; p. 42 Ahmad Al-Rubaye/AFP/Getty Images; p. 45 The Art Archive/ University Library Istanbul/Gianni Dagli Orti; p. 46 © Roger-Viollet/ The Image Works; p. 48 The Pierpont Morgan Library/Art Resource, NY; p. 51 Thomas Hartwell/Time & Life Pictures/Getty Images; p. 52 Anne-Christine Poujoulat/AFP/Getty Images

Designer: Les Kanturek; Photo Researcher: Cindy Reiman